NANTWICH

HISTORY TOUR

ACKNOWLEDGEMENTS

I would like to thank Kevin Greener for permitting me again to use some of his old photographs. Then, of course, my lovely wife Rose for her patience during the compilation of this book.

First published 2017

Amberley Publishing
The Hill, Stroud,
Gloucestershire, GL5 4EP
www.amberley-books.com

Copyright © Paul Hurley, 2017
Map contains Ordnance Survey data
© Crown copyright and database right
[2017]

The right of Paul Hurley to be
identified as the Author of this work
has been asserted in accordance with
the Copyrights, Designs and Patents
Act 1988.

ISBN 978 1 4456 6872 7 (print)
ISBN 978 1 4456 6873 4 (ebook)

British Library Cataloguing in
Publication Data.
A catalogue record for this book is
available from the British Library.

Origination by Amberley Publishing.
Printed in Great Britain.

ABOUT THE AUTHOR

Paul Hurley is a freelance writer, author and a member of the Society of Authors. He has an award-winning novel, a column in the *Mid Cheshire Independent*, other newspaper and magazine credits, and a Facebook group titled Northwich & Mid Cheshire Through Time that all are welcome to join. Paul lives in Winsford, Cheshire, with his wife Rose. He has two sons and two daughters.

Contact www.paul-hurley.co.uk
Email hurleyp1@sky.com

Books by Paul Hurley

Fiction:
Waffen SS Britain

Non-Fiction:
Middlewich (with Brian Curzon)
Northwich Through Time
Winsford Through Time
Villages of Mid Cheshire Through Time
Frodsham and Helsby Through Time

INTRODUCTION

We start our history tour of Nantwich at the pleasant village of Acton, a mile or so outside the town. It is the location of the Battle of Nantwich, and the headquarters of Lord Byron and his Royalist army were in the Church of St Mary. They had been carrying out the siege of Nantwich, firing into the town from around the church, until Sir Thomas Fairfax arrived to do battle with Byron's troops and stop the bombardment of the town. He did this successfully, and the battle is re-enacted every year by the Sealed Knot Society. Byron was separated from the main body of his army by the River Weaver, in mid-winter with lots of snow. There was a sudden thaw and the river rose, demolishing the Beam Bridge and washing away the ferry. Byron had to march 6 miles with his 1,800 cavalry soldiers to Minshull Vernon to find the nearest bridge to cross, leaving the main body of his army leaderless. The battle was decisively won by Sir Thomas Fairfax, and Lord Byron escaped to Chester with what remained of his troops. Nantwich occupies a pleasant position on the banks of the River Weaver and has been one of the most important towns in Cheshire at least as far back as the Domesday Book. The oldest and most ancient of the Three Wiches, it has had several names over the years including Warmundestrou, Wich Malbank, Helath Wen, Namptwyche and simply Nantwich. The town is second only to Chester for the number of listed buildings and, accordingly, is a place of great antiquity where black-and-white and red-brick buildings predominate.

With a county as beautiful as Cheshire, it is hard to pick out an area of special mention, but Nantwich would be in the running if one were

to be nominated. The streets are lined with ancient black-and-white and red-brick buildings of considerable antiquity, most having been built after the Great Fire of Nantwich in 1583. The narrow alleyways between the old buildings are paved with cobbles. This devastating fire was started by a man called Nicholas Brown as he brewed beer in Water Lode near to the river and burned unabated for twenty days. Fortunately, nothing across the river on the Welsh Row side was damaged, and in the other direction the fire stopped just before it reached Sweetbriar Hall in Hospital Street. This also saved that other Nantwich jewel, Churches Mansions.

Salt had drawn here since Roman times, with a break during the wars with the Welsh when Henry III had the brine pits filled up to stop the Welsh getting it, as they had done on a large scale before that. When peace with the Welsh was declared, the pits were reopened and put back to work. During the reign of Henry VIII there were some 300 salt works but by the mid-1800s the trade had declined, with the last salt house closing in 1856 leaving Northwich, Middlewich and Winsford to carry on with the trade.

Salt was not all that the town was famous for, and it was an important town during the English Civil War when it was held by Parliamentarians at a time when most of Cheshire supported the Royalists. In the first Battle of Nantwich in January 1643 the Parliamentarians under Major Lothian kicked the Royalists out of the town. Sir William Brereton of Handforth commanded the Parliamentary troops from his headquarters in the Lamb Hotel. Nantwich was besieged by Royalist forces but never fell to them. As a result, it was the only Cheshire town held continuously by the Parliamentarians. From his headquarters in Nantwich, Brereton led expeditions throughout Cheshire and Staffordshire.

As mentioned above, the Royalist base under Sir John Byron was the village of Acton, and it was from here that he put the town to siege and attempted to burn it down once again. After a while Parliamentarian troops led by Sir Thomas Fairfax fought a fierce

battle at Acton, his victory lifting the siege on the 25 January 1644, a day that was thereafter called Holly Holyday and celebrated in the town for many years thereafter with much festivity and the wearing of holly sprigs in the hair. The Sealed Knot Society still re-enact the battle on the anniversary of the Acton rout, named the Battle of Nantwich.

In this book we look at the history of Nantwich through the years – with more than 100 listed buildings in this small town there is a lot to see. We take a walk along the streets, from the village of Acton where guns were fired into the town during the siege. A map is included for those who wish to use this book during a walk. From Acton we move along Welsh Row and into the town proper, where the streets are set out in a medieval pattern – High Street, Beam Street, Barony Road and down the ancient Hospital Street into the town. Take a look down Pillory Street, the home of the excellent Nantwich Museum and Art Gallery. As you go, take the short detours to seek out other areas of this lovely town. This small book prioritises Acton, Welsh Row, High Street, Hospital Street and Pillory Street but off these streets other buildings of historical interest can be found.

The parish church of Nantwich is also called St Mary's and people born within the sound of its bells are called Dabbers, as is the football team – a Nantwich name, the origin of which seems to be lost in the mists of time. It probably originates somewhere in the broad Cheshire dialect that is spoken here by long-standing Dabbers!

Years of being laid to waste during the Norman Conquest, frequently bashed by the Welsh, set on fire, placed under siege in the Civil War and plagued by plagues has left a small and pretty town steeped in history. Unlike other towns, the usual town planning vandalism has, with exceptions, been kept to a minimum, leaving this historical town as we see it today. Buildings like the unusual Chester's/Christians building at the Hospital Street junction was a good swap for the old building that it replaced. Enjoy the captions giving details of the locations and buildings as we pass them.

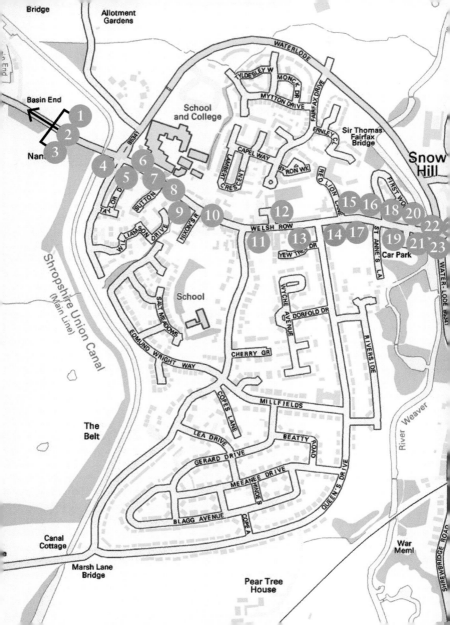

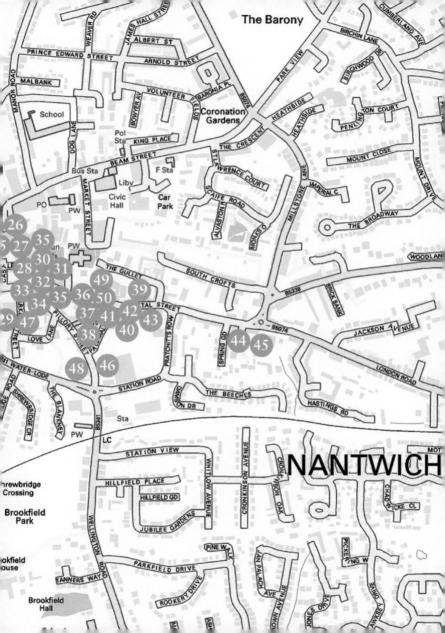

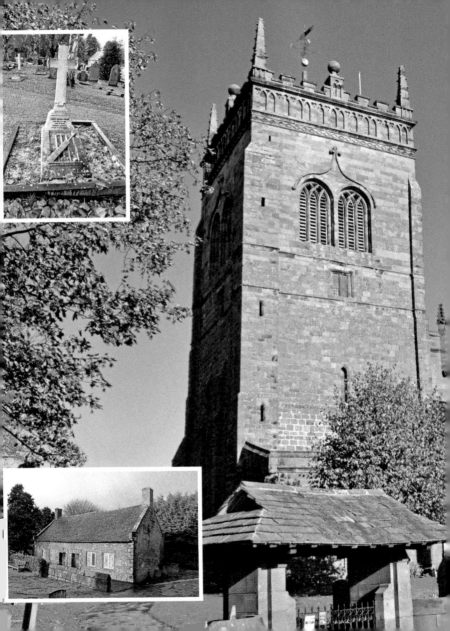

1. ACTON CHURCH, 2016

The parish church of St Mary here at Acton is a Grade I-listed building. A church on this site is mentioned in the Domesday Book in 1087 and vicars are listed from 1288. It became the mother church for Wrenbury, Minshull and Nantwich. The tower is the oldest in Cheshire, having been built in 1180. At the time of building it reached a height of 100 feet and in 1757 part of it fell in and had to be rebuilt but only to a height of 80 feet. Like the St Mary's Church in Nantwich, the interior was damaged during the Civil War. For a small village, St Mary's Grade I-listed church has always been an important and once boasted Nantwich church as its chapel of ease. The graveyard is well worth a visit if you are interested in cricket or military service. The Hornby family grave, carved from marble, is situated there and bears the names of family members who died in the war. Albert Neilson Hornby, nicknamed 'Monkey' as he was short, was one of the most famous sportsmen of the nineteenth century. He played cricket for England and in 1882 opened the batting with W. G. Grace in an encounter dubbed: 'The greatest Test match ever'. England were soundly thrashed and the following week this notice appeared in the *Sporting Times*: 'In affectionate Remembrance of English cricket which died at The Oval on 29 August 1882. The body will be cremated and the Ashes taken to Australia'. The following year the England team travelled to Australia to recover the 'Ashes' and won the series. It was in Melbourne that some ladies burnt the bail in the final match and gave the ashes to the England captain. Walter lived at Bridge House, Church Minshull and later at Parkfield, Wellington Road Nantwich, and was married to the daughter of Herbert Ingram, who founded the *Illustrated London News*. Walter died aged seventy-eight in 1925 and the wicket, bat and ball carved on the grave are a tribute to him. The third photograph is of a pair of seventeenth-century almshouses that are in the graveyard. At the moment they are boarded up.

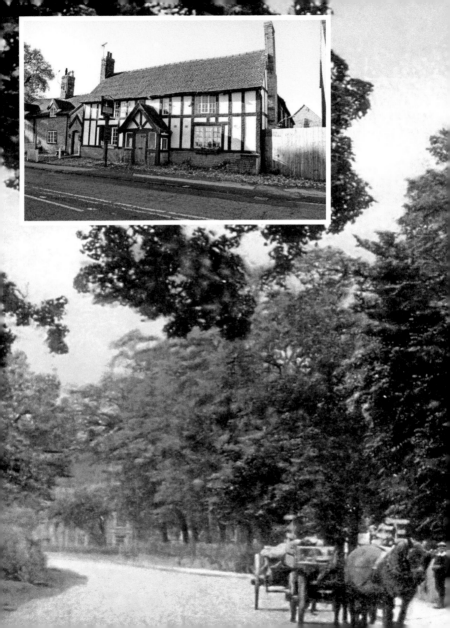

2. THE STAR INN, ACTON VILLAGE, LATE 1800s

The old photograph of the Star Inn dates to the turn of the last century. This inn dates from 1590 and in 1902, around the time of the photograph, George Boughey was both the landlord and a farmer. Note at the far right of the 2016 photograph the very well-worn sandstone steps used to alight to and from carriages and horses. At the time of writing it is yet another closed country pub. Acton means *Actune* or 'Oak Town'. Delamere Forest actually reached this far at one time.

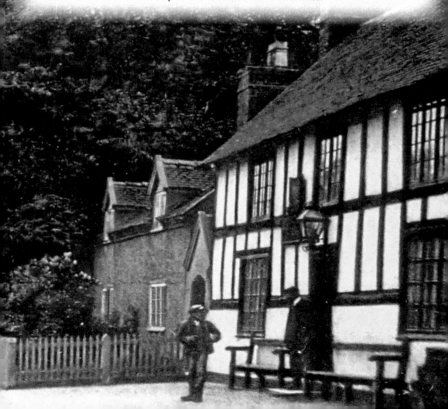

3. DORFOLD HALL

As we leave Acton for Nantwich, we pass the drive on the left leading to the Grade I-listed and magnificent Jacobean Dorfold Hall. Built as a mansion by Ralph Wilbraham in 1616, the lands had been left to him by Sir Roger Wilbraham, his brother. During the English Civil War in 1644 battles took place on the estate lands. During the Second World War, evacuated children from Liverpool stayed there and Canadian and American troops camped in the grounds. Parts of the estate were demolished after the war, but in 1946 the famous Nantwich Show was held there and does so each year. Naturally such a beautiful building would attract film companies looking for a period location and so it has been with Dorfold. Famous historian Nicolas Pevsner classed Dorfold Hall as one of the two finest Jacobean houses in Cheshire.

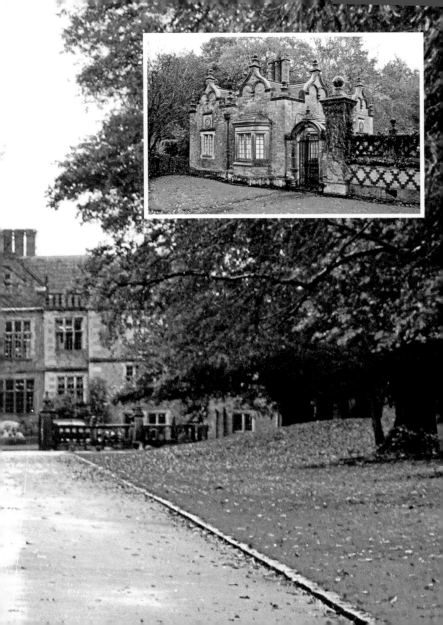

4. NANTWICH AQUEDUCT, LATE 1800s

As we continue towards Nantwich, we have to pass under the attractive canal aqueduct This aqueduct was built in 1826 by Thomas Telford to carry the Shropshire Union Canal over Chester Road. It was constructed in cast iron with a water trough and cast-iron balustrade and carries the Shropshire Union Canal across the road. The canal started life as the Birmingham & Liverpool Canal, which started in Nantwich, opened in 1845, and went on to join the Chester Canal and onwards through the country. This aqueduct is a Grade II listed.

5. WELSH ROW HEAD, EARLY 1900s

Crossing the crossroads we enter Welsh Row and, as we look to our right, we see a large three-story building in an area that is still known as Welsh Row Head. The building is No. 165 Tannery House, a Grade II-listed building built in the late 1800s. The resident in 1902 was Mrs Harriet Blud William, a fellmonger, which means a dealer in hides or skins, hence the name Tannery House. There is a new housing development in this area now known as Tannery Court. The art of the fellmonger is an ancient one as man has always clothed himself in animal skins of one kind or another. A fellmonger was the expert in stripping hides from animals, in many cases, sheep.

Wels

Row Head, Nantwich,

6. ALMSHOUSES AND GRAMMAR SCHOOL

Into Welsh Row proper now, an ancient road that leads us into Nantwich town. The reason for the name Welsh Row comes from the fact that the Welsh used to come into town this way to collect their salt. The road also avoided the Great Fire of Nantwich, and it was called Frog Lane in the old days as there was an open drain from Welsh Row Head to the River Weaver; this drain was filled in during 1865 when more modern drainage replaced it. The large building on the left is the Nantwich & Acton Grammar School. Built in 1921 to replace the one built in 1860 at No. 108 Welsh Row. This in turn was built to replace the one from 1572. It is now Malbank School & Sixth Form College. After this we pass two very pretty rows of what were once almshouses, built in 1870 by the Tollemache family to replace the original seventeenth century ones a little further on.

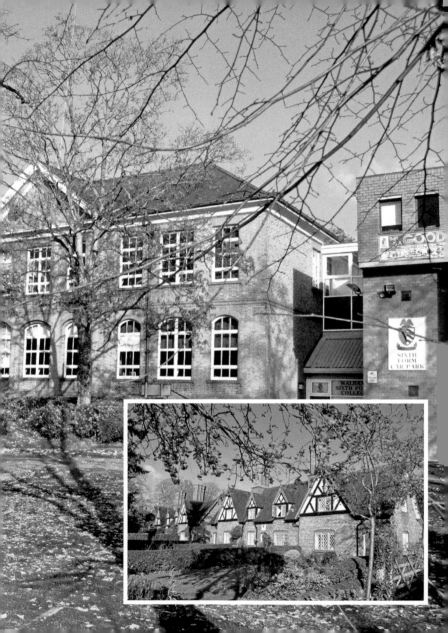

7. ALMSHOUSES, WELSH ROW, *c*. 1900

As we start towards Nantwich, we do not go far before we find a black-and-white house on the left called Malthouse Cottage. This was once a row of black-and-white almshouses built in 1676 and provided by Sir Roger Wilbraham for six poor men. This building was split into six compartments, and when one became vacant the descendants of the founder would allocate them on the recommendation of 'some of the respectable inhabitants!' of the town. The two rows of almshouses next door were built in 1870 to replace these older ones. One of the later tenants, probably the one in the old photo, was Achilles (Archie) Davenport who nailed a plaque above the door saying 'AD 1502'. He was a bit of a humourist and this was not the date of building. It was his initials and his works number at Crewe Works.

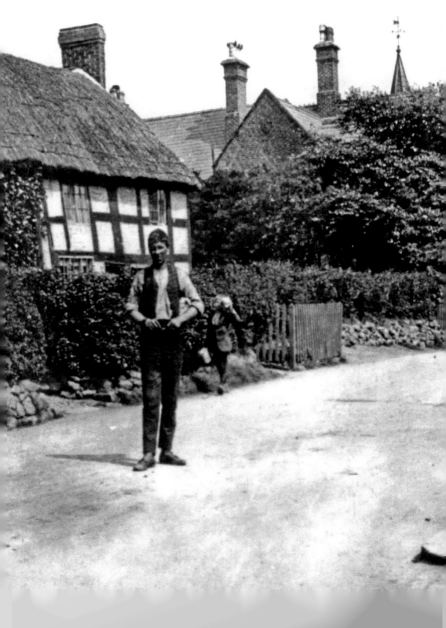

8. THE OLD GRAMMAR SCHOOL, 2016

We now reach No. 108 Welsh Row, which was once the Nantwich Grammar School and headmaster's house. It was built in 1860 by George Wilbraham of Delamere to replace the Blue Cap School that existed from 1700 to 1852 and Acton Grammar School, founded in 1662. It was replaced, as mentioned earlier, by the purpose-built school from 1921.

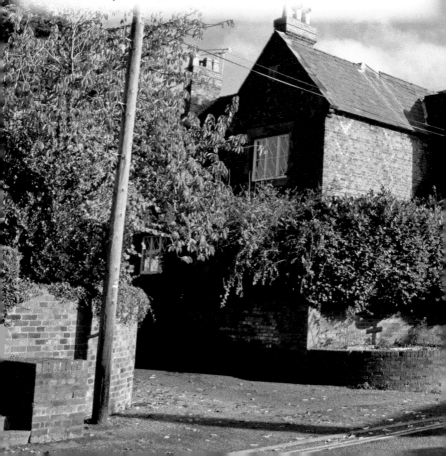

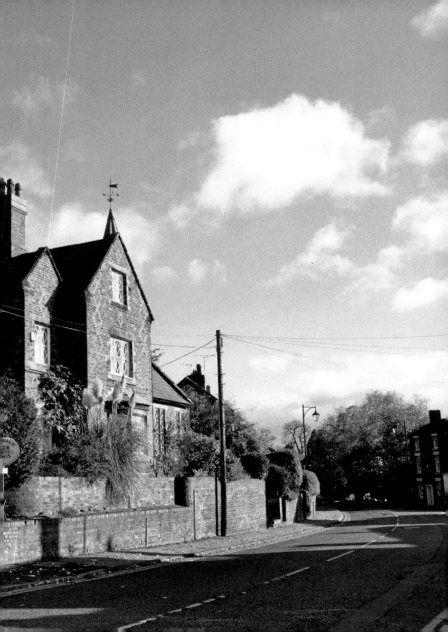

9. THE GATEWAY, 1900s

We travel further along Welsh Lane now and pass two prestigious buildings. The first is the Gateway, built in the early nineteenth century, and the stable entrance to Porch House, which was once the home of the Wettenhall family. Then, in the early twentieth century, it was a solicitor's premises and a boarding school for girls. It is a beautiful eighteenth-century red-brick town house that has now been converted into two dwellings. It stands on the site of an earlier fifteenth-century mansion with same name. In 1470 the house was inherited by Henry Wettenhall of Dorfold Manor. During the First World War it was used to house Belgian refugees.

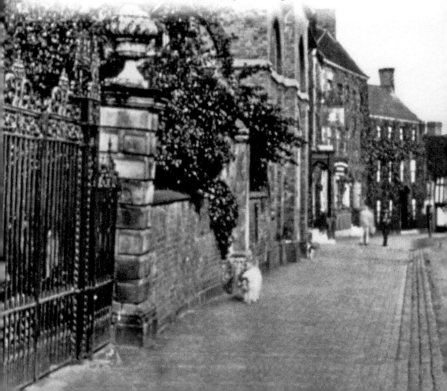

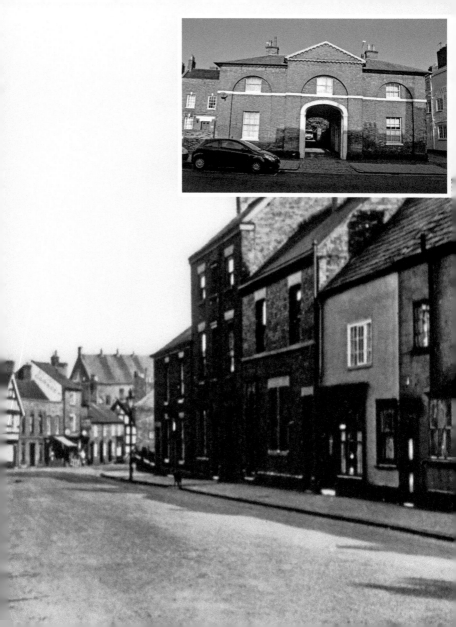

10. THE WILBRAHAM ARMS, 1950

As we pass the Gateway we reach the Wilbraham's Arms pub on the left with its central porch supported by wooden posts. It dates from the late eighteenth to early nineteenth century and was originally called the Red Lion (the road at the side is still called Red Lion Lane). The present name was a tribute to Roger Wilbraham Esq. who provided the two sets of almshouses in the road: the Cheshire Cat building for women and the one at Welsh Row Head for men. The pub closed suddenly last year but is up and running again now.

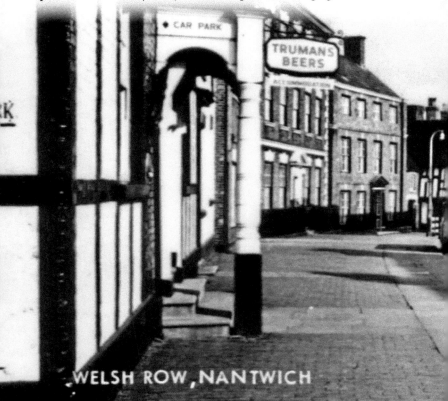

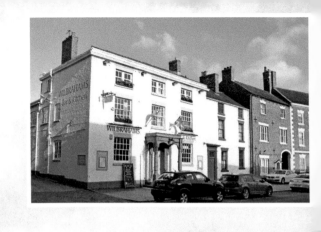

11. WHITEHALL, NO. 49 WELSH ROW, EARLY 1900s

In the same area of Welsh Row we look to the right and see a row of modern and upmarket terraced houses. These were built on the site of the large prestigious black-and-white building known as Whitehall, as seen here. The address is still Whitehall, with each house being numbered 1 to 4 Whitehall, Welsh Row. This too had been the home of the Wettenhall family in the seventeenth century, and in 1902 Edwin Bayliss and his family were in residence and sold antiques from the house. By 1906 its name was Edward Bayliss. But as time went on, it was allowed to fall into disrepair, which eventually led to its demolition and the building of the modern row.

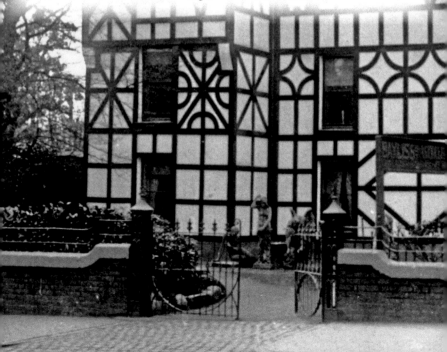

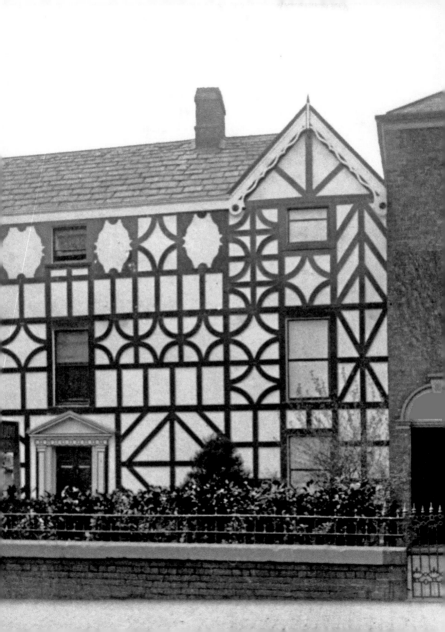

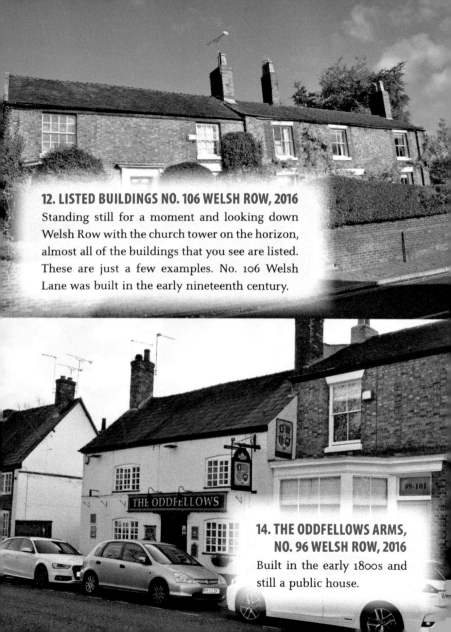

12. LISTED BUILDINGS NO. 106 WELSH ROW, 2016

Standing still for a moment and looking down Welsh Row with the church tower on the horizon, almost all of the buildings that you see are listed. These are just a few examples. No. 106 Welsh Lane was built in the early nineteenth century.

14. THE ODDFELLOWS ARMS, NO. 96 WELSH ROW, 2016

Built in the early 1800s and still a public house.

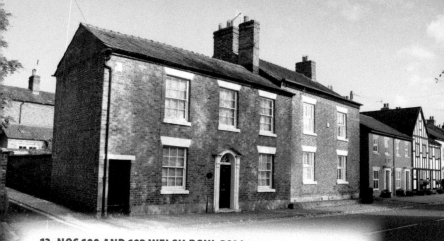

13. NOS 100 AND 102 WELSH ROW, 2016

A pair of red-brick houses also dating from the early 1800s.

15. TOWNSHEND HOUSE, 2016

The house on this site was the original home of the Wilbraham family from 1580 to 1780. James I stayed at the house in 1617. The original arched gateway still exists and has been moved to the grounds of Dorfold Hall.

16. THE OLD NANTWICH POLICE STATION

This is not a listed building but is the original Nantwich police station that was exchanged for a small one in Beam Street.

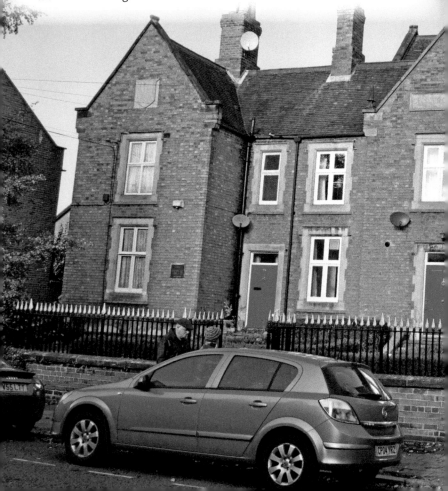

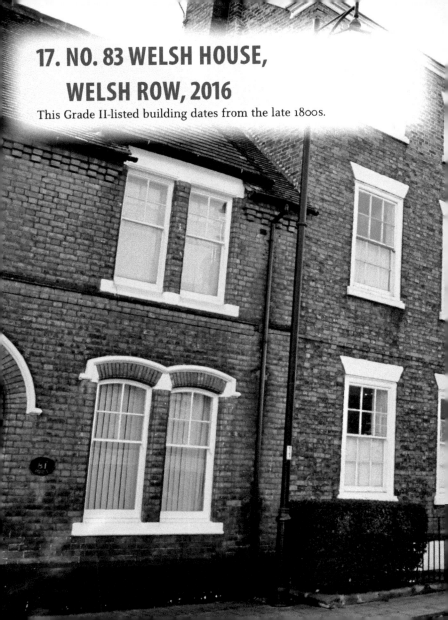

17. NO. 83 WELSH HOUSE, WELSH ROW, 2016

This Grade II-listed building dates from the late 1800s.

18. NOS 46–48 WELSH ROW, *c.* 1900

This black-and-white building overhanging the footpath dates to the seventeenth century or earlier, with later additions. The three-story building on this side of it is No. 50, built in the mid-eighteenth century and the two-storey row beyond it, No. 42 and No. 44, date from the late eighteenth century.

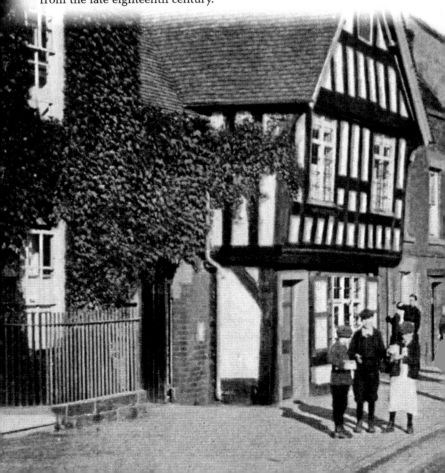

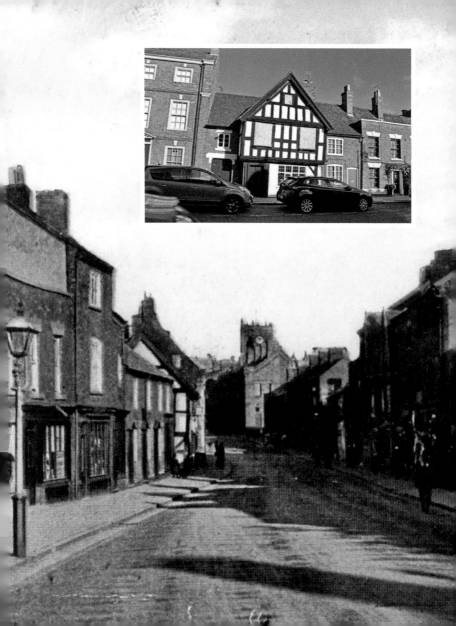

19. NO. 39 WELSH ROW

This attractive building was built as a bank in 1846 and is Grade II listed. Nikolaus Pevsner described it as: 'The first noteworthy building on Welsh Row.' This from a man who had already described Welsh Row as: 'The best street in Nantwich!' In 1850 the bank only opened twice monthly, on the first and third Monday. It was then only one of two banks in Nantwich, the other one being a branch of the Manchester & Liverpool District Bank. By 1874 this bank opened weekly. By 1930 it had amalgamated with the Chester-Wrexham District Savings Bank, later a branch of the TSB relocated at No. 29 High Street. The building was neglected and now houses offices.

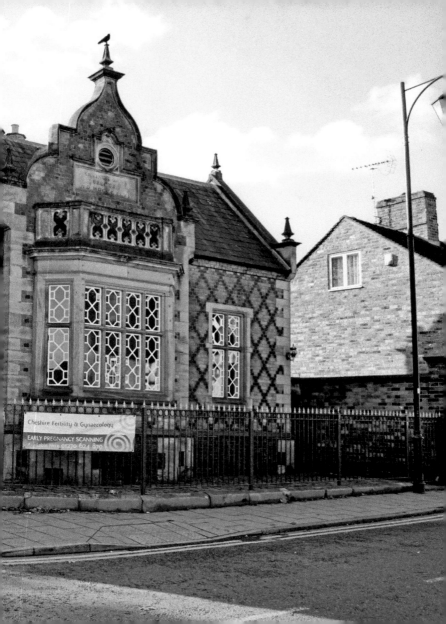

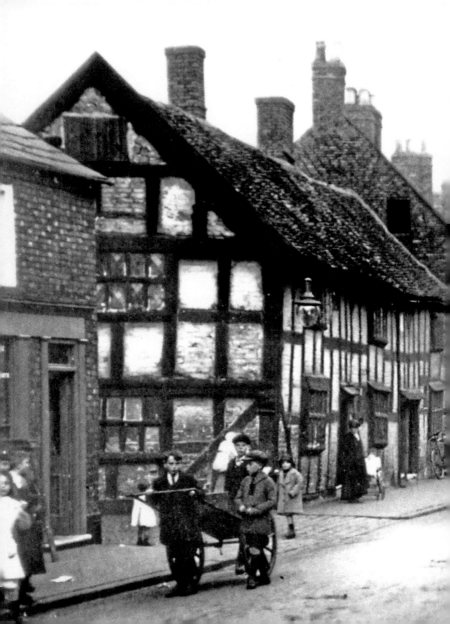

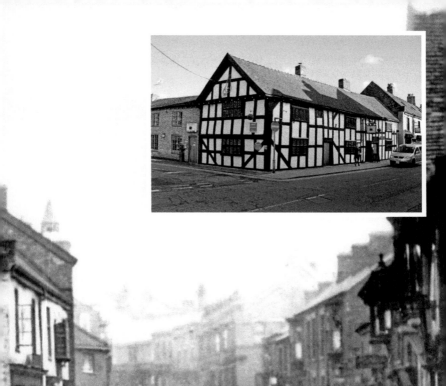

20. THE CHESHIRE CAT, 1920s

Founded in 1676 as an almshouse by Roger Wilbraham, who endowed it with an annuity of £24 per year for ever! The house was for the benefit of widows and it comprised three tenements of brick and wood, with two widows residing in each. They received 17s 6d per quarter and 6s 8d per year for coal and were given a gown and a petticoat once every two years. Also 'two old maids occupied a separate cottage.' The building went on to other uses and names, such as a night club, and is now once again The Cheshire Cat Hotel.

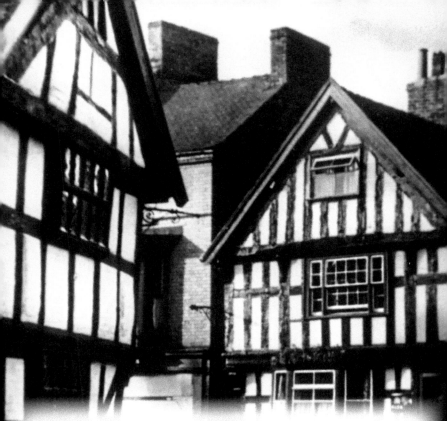

21. THE BLACK LION INN

Directly opposite The Cheshire Cat is an ancient pub, built in 1664, which was just twenty years after the Battle of Nantwich, the oldest pub in the town that has always been a pub. It has a timber frame and brick and plaster infilling, with wattle and daub throughout. A traditional pub with great antiquity, it has, like the rest of the area, changed little over the years. It was a coaching inn on the road from Chester to London for many years. At the side of the pub is Gas Alley, which led to the Nantwich gasworks at the rear.

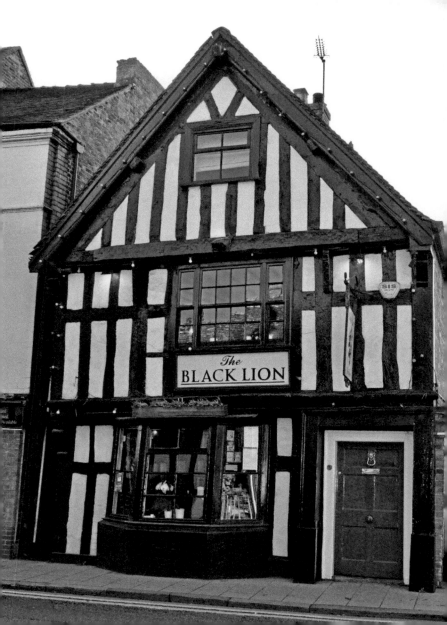

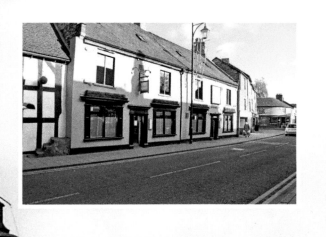

22. THE THREE PIGEONS, 1800s

Now to a building that was once a pub called the Three Pigeons, next to The Cheshire Cat. As we pass The Cheshire Cat, look down at the set of sandstone steps (mounting block). They were put there in the seventeenth or eighteenth century and were used by farmer's wives to alight from the back of their husband's horse or from a carriage. This block is Grade II listed in its own right. The pub was originally known simply as Pigeons in 1860 when Elizabeth Bayley was the licensee. Later on it became the joining point for the coach to Tarporley and Bunbury. There was a cockpit at the rear of the pub where the sport of cock fighting took place. There were also stables for the huntsmen.

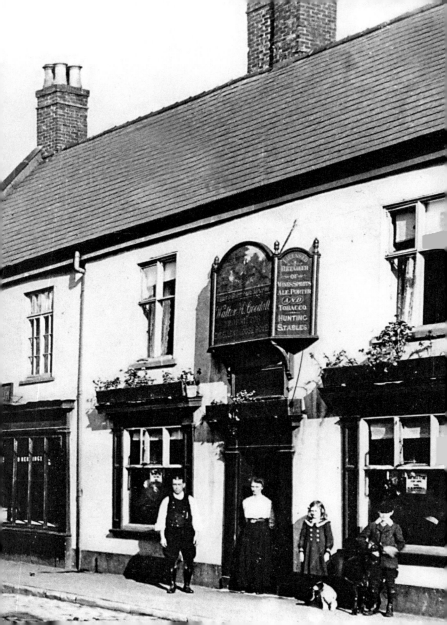

23. WELSH ROW TOWARDS THE BRIDGE *c.* 1910

Reaching the end of Welsh Row now and approaching the old bridge that will take us across the River Weaver. In the old photograph, the main building of note is the town hall, on the left and over the bridge. Built in 1803 at a cost of £2,531, over the years it incorporated the Corn Exchange, the Mechanics Institute, the County Court and the offices of the Board of Health. It remained the town hall until the 1960s when it was deemed unsafe and demolished – quite convenient really as that side of the street was being demolished for road widening anyway!

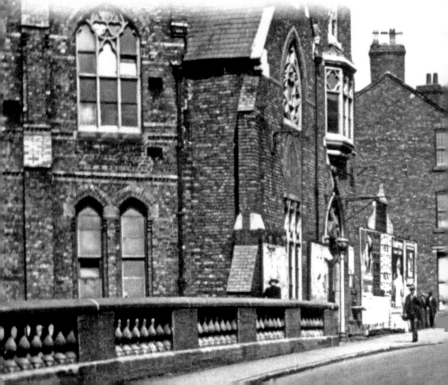

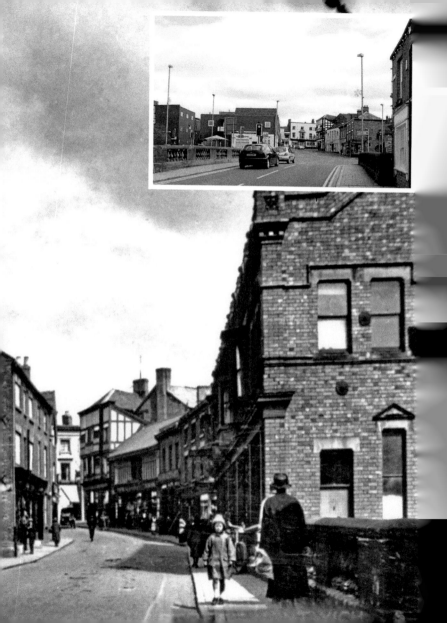

24. NANTWICH BRIDGE, WELSH ROW, c. 1910

As we cross the bridge, we are walking across history; for it is this bridge, or rather its wooden predecessor but one, which had been there since 1663, that became an important obstacle in the Siege of Nantwich during the Civil War The present single-span stone-built bridge dates from 1803 and is Grade II listed. During the coaching days, this was the main road from London to Wales and passes over the River Weaver. In the thirteenth and fourteenth centuries the bridge at this location was wooden and called the Wich or Wyche Bridge and had St Anne's Chapel and four shops built upon it. As we cross the bridge, we enter the road known as Water Lode, and it is at this location that the brewer managed to set fire to the town. If we look to the right while on the bridge, we will be looking in the general direction of what is called The Old Biot, which was a salt spring in the bank of the River Weaver. Its location was cleared away by volunteers from the Rotary Club of Crewe. There is still a salt spring there, as there was in the heyday of salt recovery in Nantwich many years ago.

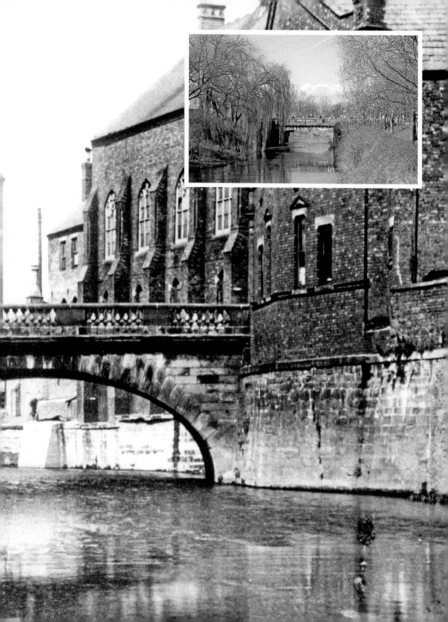

25. HIGH STREET, 1920s

Crossing Water Lode and into the High Street, we see the extensive alterations that have been carried out. The block of shops on the left will all be swept away to make way for what you see in the new shot. The twin-hipped building in the centre will be demolished but the pub behind it still remains, with its adjoining buildings. The one building that predominates the scene is the black-and-white Regent House and the adjoining Warwick House that is around the corner.

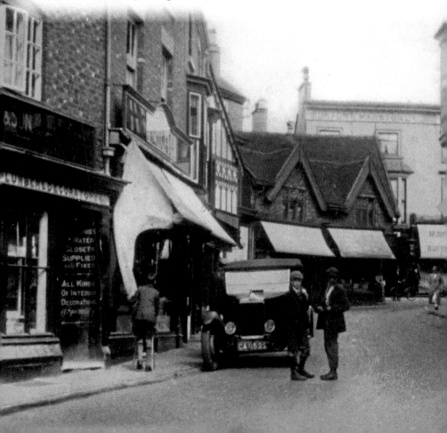

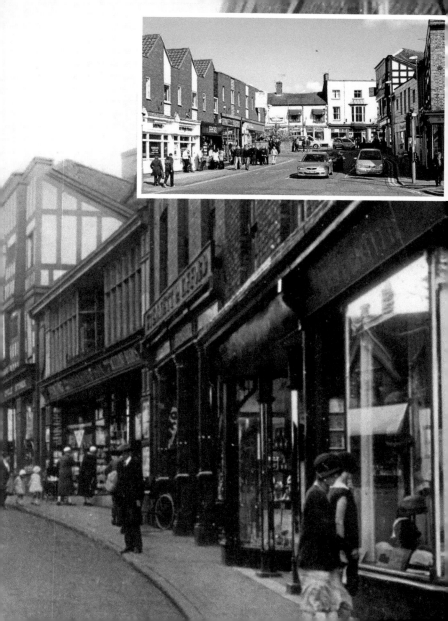

26. WARWICK HOUSE AND REGENT HOUSE, 2016

A look now at the buildings that are viewed from further down the High Street. Both of these connected buildings are Grade II listed and were built shortly after the Great Fire, around 1584. This was the location of Nantwich Castle, which was built before the tenth century, or rather at the rear of these buildings. The buildings are now shops, one of which at the time of writing is up for rent or sale.

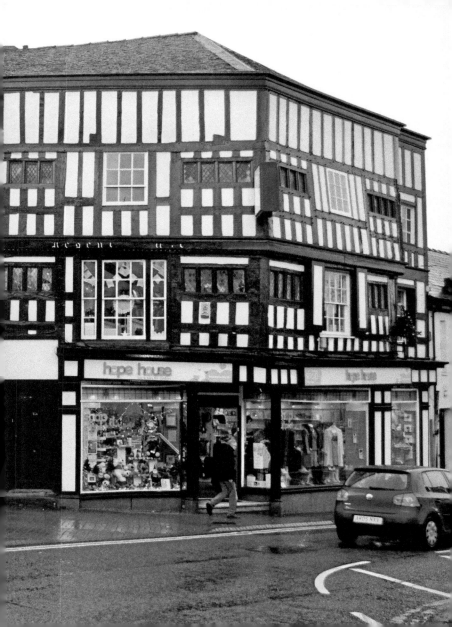

27. THE CROWN HOTEL, 1950s

The Crown Inn, now the Crown Hotel, is a timber-framed building that was rebuilt shortly after the 1583 fire. It was once the principal inn of Nantwich. The beautiful frontage of the building features close studding and ornamental panels. Each story overhangs slightly and has carved brackets. Along the second floor there are continuous windows that once fronted a long gallery, which was partitioned into smaller rooms in the eighteenth century. At the rear of the building there is an assembly room that was used as a place of worship during the Civil War and the siege. It is a beautifully presented Grade I-listed building that retains as much of its character within as without.

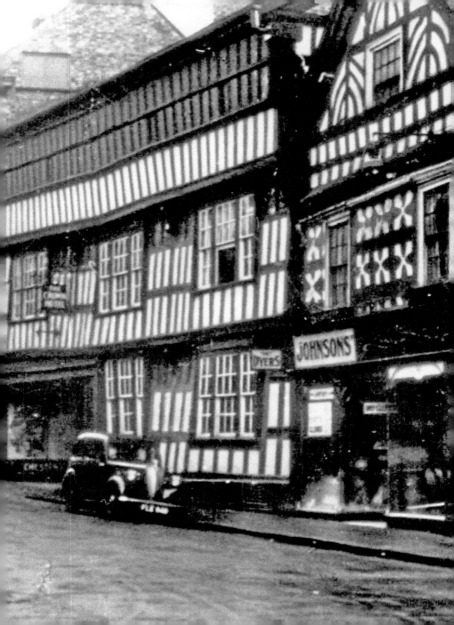

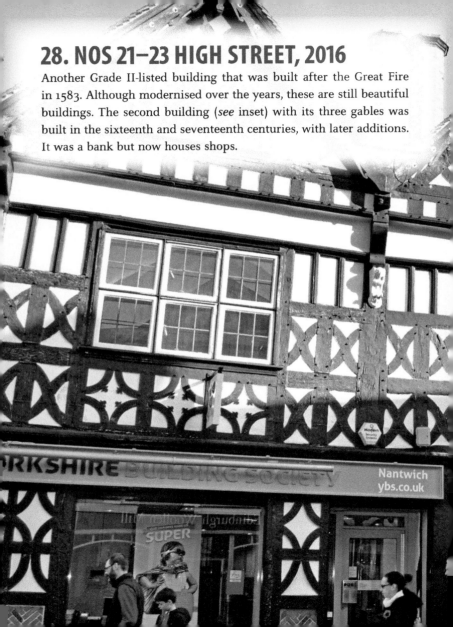

28. NOS 21–23 HIGH STREET, 2016

Another Grade II-listed building that was built after the Great Fire in 1583. Although modernised over the years, these are still beautiful buildings. The second building (*see* inset) with its three gables was built in the sixteenth and seventeenth centuries, with later additions. It was a bank but now houses shops.

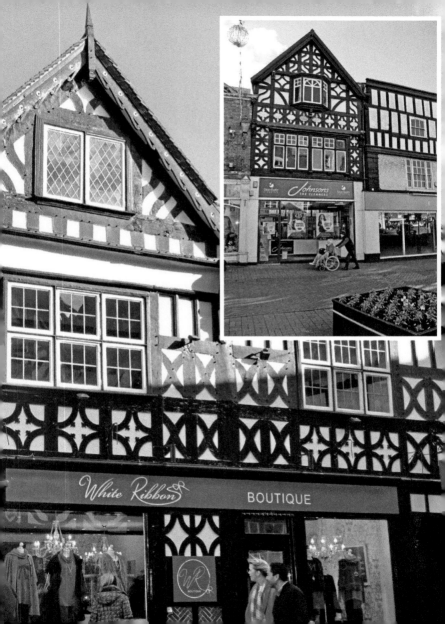

29. WAR MEMORIAL, 1920s

The Nantwich War Memorial sits on an area that has been pedestrianised and surrounded by benches and flowers. It was unveiled in 1921 by Lieutenant-General Sir Beauvoir de Lisle. In the old photograph, taken shortly after the unveiling, we can see a nice selection of period cars. There are more names on the memorial now as a result of the Second World War, and no doubt more names will unfortunately continue to be added.

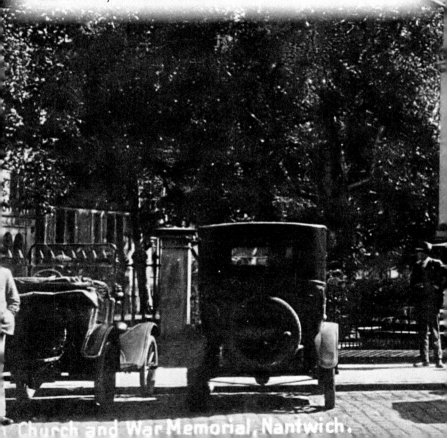

Church and War Memorial, Nantwich.

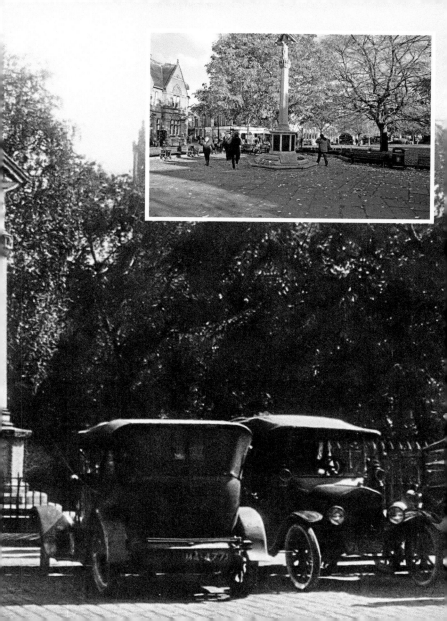

30. TOWN SQUARE, EARLY 1915

As we pass the war memorial, we enter Nantwich Town Square, which used to be the bus station. The early 1900s photograph shows the printing office of Alfred Edward Hill, a printer and bookseller, and the modern shot shows a black and white building has been erected and was and still is a WHSmith. This was the bus stop for the Nantwich and Crewe Motor Bus Company. Its service between the two towns started in 1905, not long after this photograph was taken.

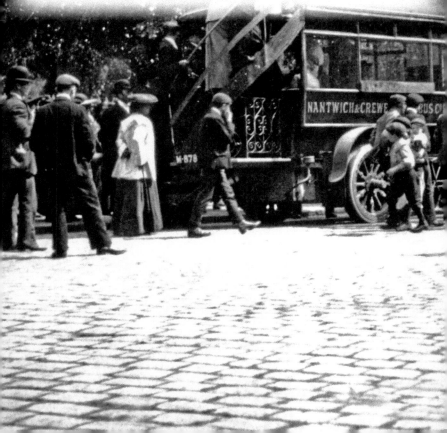

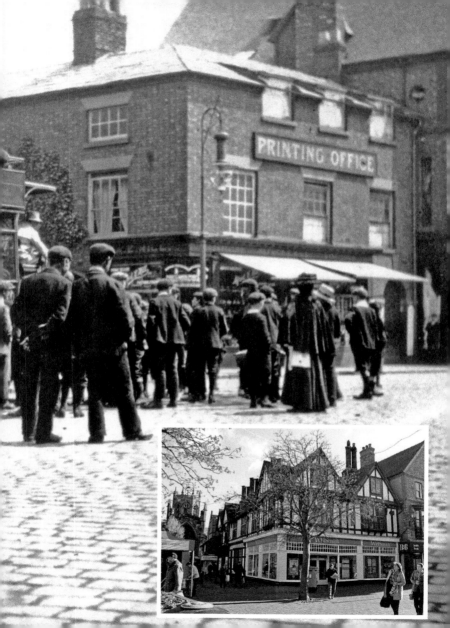

31. TOWN SQUARE ANOTHER COMPARISON 1910 AND 1920

Looking now at two comparison shots just five years apart. In the 1920s shot, the printing office has been replaced by the black-and-white WHSmith building that is still there today. I say replaced but in a lot of cases it entailed just altering the building externally. This photo shows the scene in 1910 and the inset shows it ten years later. Note that, like the printing office, the controversial building on the Hospital Street junction was built between these two dates in 1911.

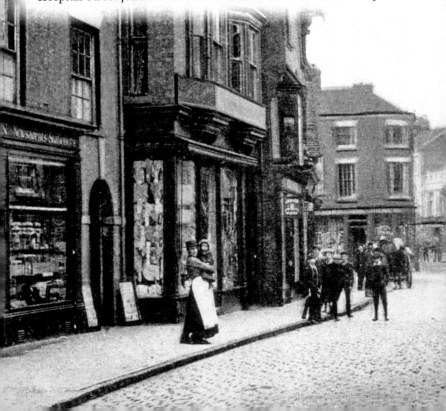

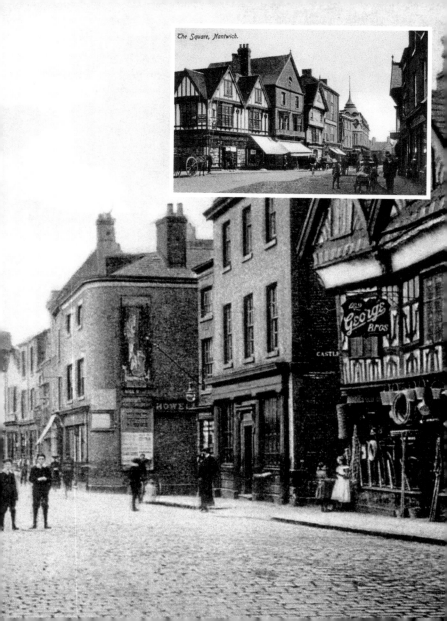

The Square, Nantwich.

32. BUTTERMARKET, 1860s

Passing WHSmith and looking back we see the oldest photo in the book, taken in the 1860s at the dawning of photography, as the quality of it reflects. The Market Hall that can be seen in this old photograph is a small building supported by granite pillars. It stands roughly where the outdoor market occasionally takes place today, and the buttermarket was held there every Saturday. This market hall was demolished in 1868 when the new one was built in Market Street.

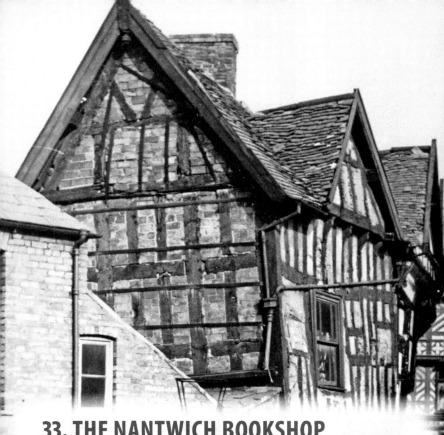

33. THE NANTWICH BOOKSHOP

This beautiful building stated life as a large Elizabethan merchant's house. It was built for Thomas Churche of the Churche family, a very well-known linen merchant and one of Nantwich's best-known families at the time. The house remained in the Churche family until the 1800s. As can be easily seen, Nantwich High Street was the home of the wealthiest residents and the buildings, all of which were built soon after the fire, reflect this. The bookshop is a Grade II-listed building and is one of the best examples of Elizabethan architecture.

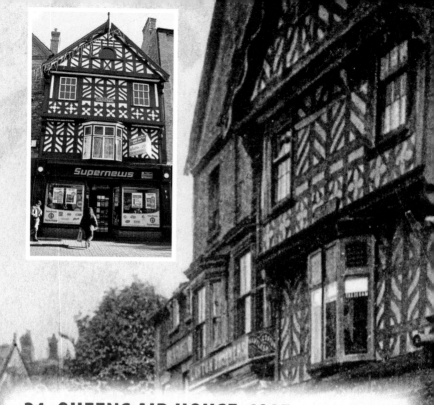

34. QUEENS AID HOUSE, 1905

The front of the building, No. 41 High Street, which was built after the fire in 1584, has an inscription thanking the queen for her aid in rebuilding the town: 'GOD GRANTE OVR RAYAL QVEEN IN ENGLAND LONGE TO RAIGN FOR SHE HATH PVT HER HELPING HAND TO BUILD THIS TOWN AGAIN.' There is also a tribute to the builder. After the Great Fire of Nantwich in 1583 Elizabeth I gave, some say, £1,000 (£200,000 in today's money) and some say £2,000 towards the rebuilding. Nonconformist preacher Mathew Henry died here while stopping for the night on his journey from Chester to London in 1714.

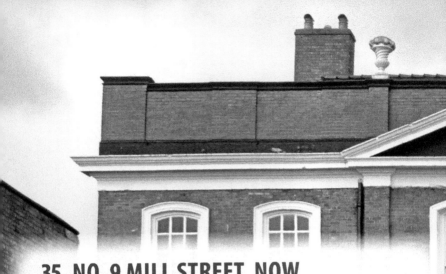

35. NO. 9 MILL STREET, NOW THE RESIDENCE, 2016

After a short deviation off the High Street and down the side of the Nantwich Bookshop we find a large prestigious building that now houses 'The Residence'. It was built in 1736 with later additions and is a Grade II-listed building. English Heritage describes it as a substantial and well-detailed early Georgian town house. It stands on the site of an earlier seventeenth-century house, which has been identified with the residence of the Wright family. In the 1600s it was one of the five principal houses of Nantwich. Sir Edmund Wright became lord mayor of London from 1640–41. This house was built in 1736 as a town house. In 1852 it became the Nantwich branch of the Manchester & Liverpool District Bank. Nantwich Liberal Club acquired the somewhat run down building in 1897. It was renovated and spent much of the twentieth century as a political club; this closed in the 1990s and the building then went on to house The Riverside Club, Peppers Restaurant and now The Residence restaurant and bar.

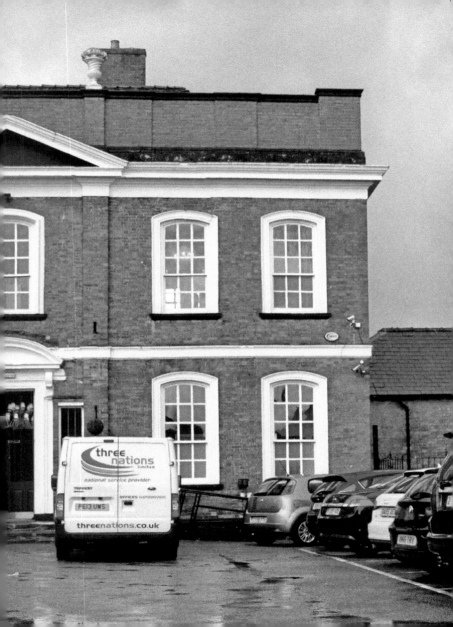

36. CHESTER'S HOSPITAL STREET, 1901

We continue along the High Street now, passing the early nineteenth-century Grade II-listed pub Ye Olde Vaults and several other listed buildings in this historical street. We then reach a quite spectacular building on the corner of Hospital Street and Pillory Street. What is now a 'wedding cake' building on the Hospital Street side is a clothing shop called Pockets, and on the Pillory Street side is Clive Christian's luxury furniture company. But when the old photograph was taken in around 1901, the building had only nine years of its old life left; it would be demolished in 1910 and the road widened. The new building, built in 1911, designed by local architects Bower and Edleston, was not to everyone's taste. Whatever the locals said at the time of construction, this has to now be described as a beautiful building and an asset to the town.

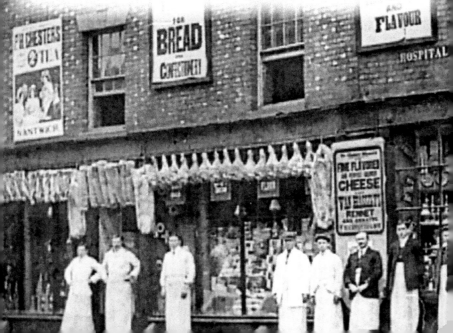

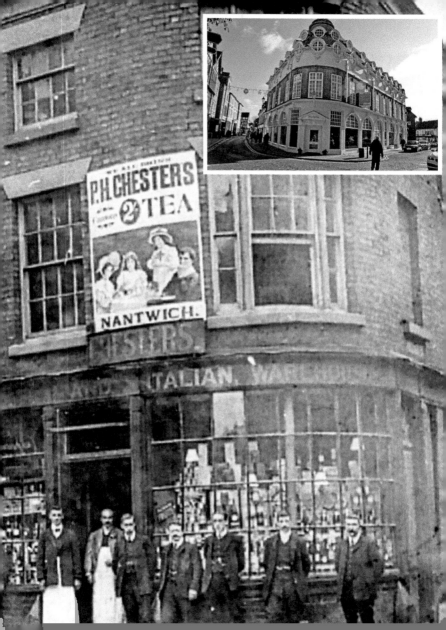

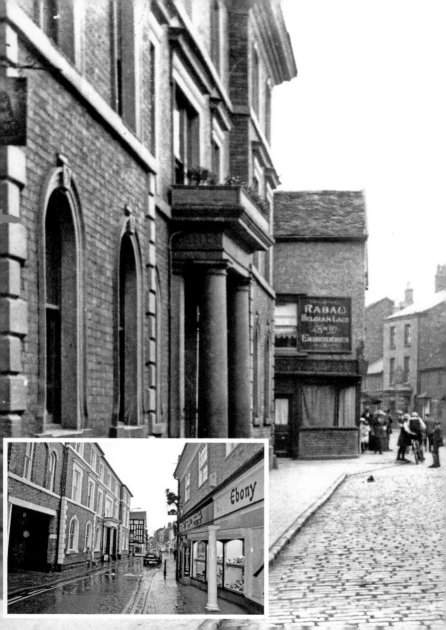

RABAS
BELGIAN LACE
AND
EMBROIDERIES

Ebony

37. THE LAMB INN, HOSPITAL STREET, 1890s

We now walk into Hospital Street to the Lamb Inn, or Chatterton House as it is called. In the 1800s it was known simply as the Lamb Family & Commercial Hotel. It is Grade II listed and was built in 1861. It's no longer a hotel as it was converted to apartments, shops and a restaurant in 2004–06 after a long period of neglect. An inn has stood on this site since around 1554 and was the headquarters of the Parliamentary troops during the English Civil War. Nantwich was an extremely important town during the Civil War because in the mainly Royalist Cheshire it leaned towards the Parliamentary cause. In fact, Sir William Brereton of Handforth commanded the Parliamentary forces of Cheshire from his headquarters at the inn on this site.

38. GARNETS CORNER, HOSPITAL STREET

Looking back down Hospital Street into High Street/Pillory Street, we see the building that was on the corner plot on the right. It was known as Garnett's Corner and was cleared to make way for the large shop that was to house Edward R. Pooley Drapers. This building can be seen in the modern photo. This new building at Garnett's Corner has now become Namptwyche Buildings, as can be seen on the sign at the front. This building would receive some refurbishment later on to leave what we can now see in the new photo. Note how the buildings in High Street have hardly altered.

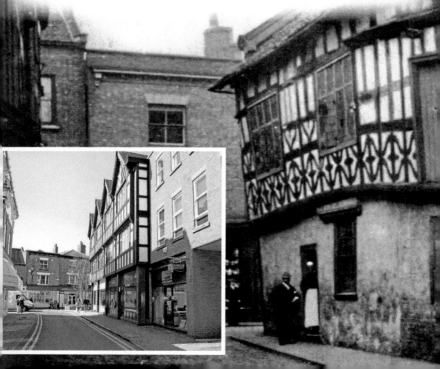

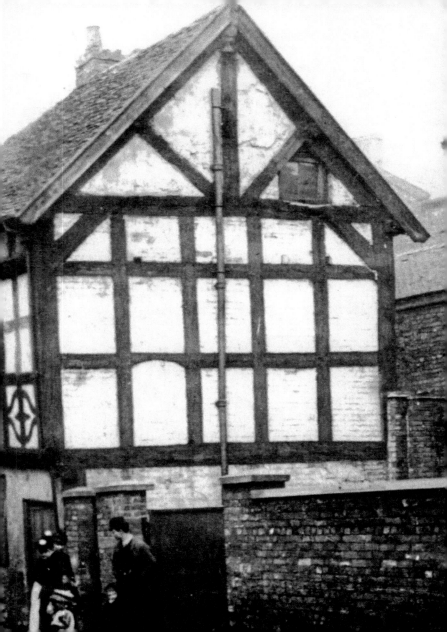

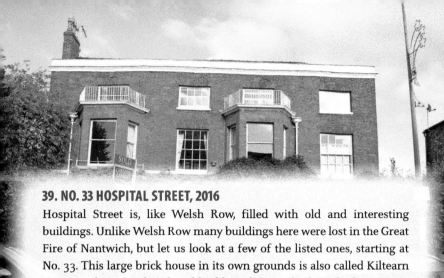

39. NO. 33 HOSPITAL STREET, 2016

Hospital Street is, like Welsh Row, filled with old and interesting buildings. Unlike Welsh Row many buildings here were lost in the Great Fire of Nantwich, but let us look at a few of the listed ones, starting at No. 33. This large brick house in its own grounds is also called Kiltearn House and is a Grade II-listed building that was built in the late 1700s.

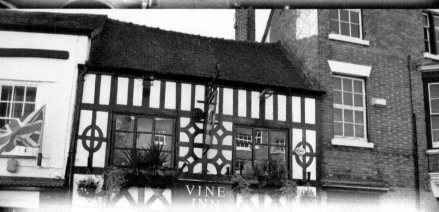

40. THE VINE INN, NO. 42 HOSPITAL STREET, 2016

This popular Grade II-listed public house has defied the trend and is still serving its customers. It was built in the 1800s on two floors and has a sham-timber frame set onto its original timber frame.

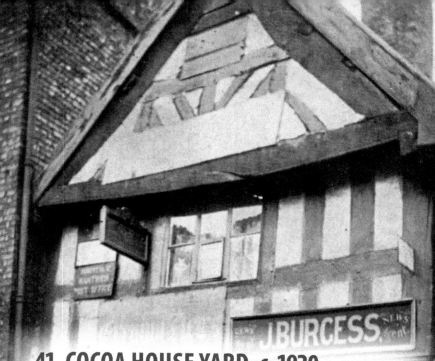

41. COCOA HOUSE YARD, *c.* 1920

This passageway, known as Cocoa House Yard, was named after the
Cocoa House in Pillory Street at the other end of the path – during
the Victorian period there was a strong Temperance movement, which
aimed to open cocoa houses as opposed to public houses. The premises
at the Hospital Street end, before the path was opened up, are shown in
this old photograph, a well-stocked newsagent and a post office owned
by the Burgess family and situated in an ancient shop positioned
between larger buildings. Eventually, the need for redevelopment
arose and the shop was demolished. It is now the entrance to Cocoa
House Yard. On the newspaper adverts, mention is made of the budget
and Chamberlain, possibly referring to Neville Chamberlain, who was
Chancellor in the mid-1920s. This dates it to around then.

42. WELCH'S DELICATESSEN, 2016

From outside we are simply looking at a small delicatessen, so why is this mentioned in a history tour? You have to go in to find out. This building is a veritable Tardis – even these photos don't do justice to it. There is a fully stocked 1950s shop behind plate glass, with groceries and manikins, going by the name of Austin's, the name on the grocer's bike propped up in the doorway. A long corridor lined with goodies leads you to another counter and a door. Through the door you will find the museum and a large café/restaurant. As I wrote in the *Cheshire Life* in a review of the establishment, it is one of Nantwich's hidden gems.

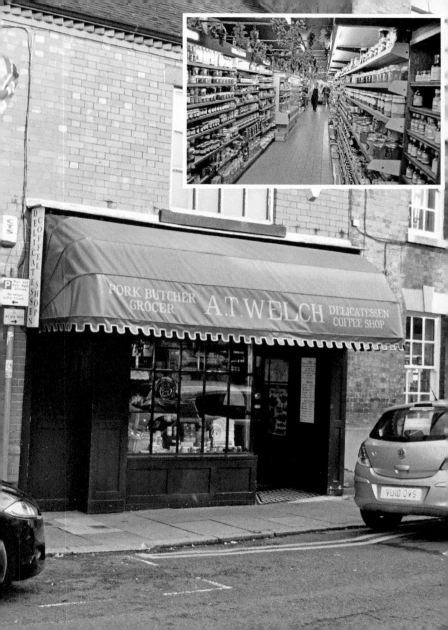

43. SWEETBRIAR HALL, HOSPITAL STREET, EARLY 1900s

Over the years, the Grade II-listed Sweetbriar Hall saw changes in its fabric, the railings were removed, probably for the war effort, and during the '40s and '50s it was allowed to fall into a somewhat neglected state. Accordingly, a full refurbishment was carried out by the architect James Edleston, leaving the building that we see today. Sweetbriar Hall was built before the Great Fire of 1583 for the Wilbraham family and later the birthplace of Sir William Bowman, noted surgeon and one of the greatest investigative doctors of the nineteenth century. Another famous resident was Joseph Priestly (1758–61) when he was a local Unitarian Minister. The house he occupied, which was once a school, is in the grounds of the hall. He was later elected a Fellow of the Royal Society in 1776. This honour was mainly in recognition of his writings on electricity, but he is mainly remembered today for his discovery of oxygen. The fire of 1583 took the house next to the hall but finally ended its devastation there, saving the hall. The timber-framed building built in around 1450 was later rendered and pebble dashed, as can be seen in the old early twentieth-century photo.

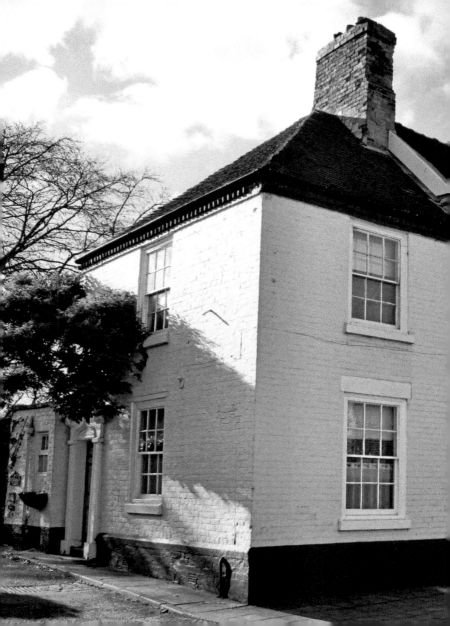

44. NOS 140–142 HOSPITAL STREET, 2016

Known as Hospital House, it is believed to stand on the site of the medieval Hospital of St Nicholas from where the name Hospital Street originated. It is a Grade II-listed building that dates from the late 1500s and was built by a gentleman by the name of John Crewe, a tanner whose sons Randolph and Thomas both spent time as Speaker of the House of Commons. It was originally timber framed but has been altered over the years. It is believed that John Crewe gained slight notoriety by owning the house in which Nicholas Brown lived when he started the fire that burnt down most of Nantwich in the Great Fire. Brown was brewing in a property that he rented from Crewe in Water Lode in 1583 when a fire started, explained at the time as being: 'Through negligence of undiscreet persons brewing.'

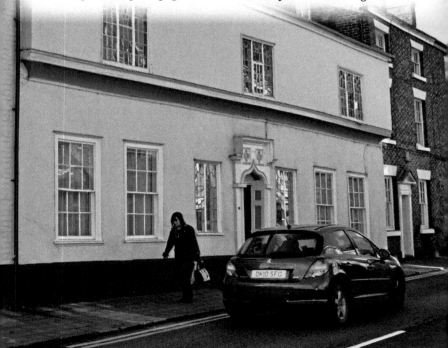

45. CHURCHES MANSIONS

In the mid-1400s the Churche family moved from Leicestershire to Cheshire and purchased a property in Hospital Street. It was a good move and the family prospered, buying up properties in Cheshire and Shropshire. Richarde Churche was born in 1540 and married Margerye Wright, the daughter of another wealthy Nantwich family. Richarde had the mansion built for him and his wife in 1577. The master carpenter Thomas Clease, who had already worked on Little Moreton Hall, did the work. In the second half of the fifteenth century after the Wars of the Roses, the feudal power of the nobles declined dramatically. There are only a few merchant houses left from this period as most were in towns and were redeveloped.

The house was quite new when the Great Fire of Nantwich consumed most of the town but fortunately stopped before it reached the mansion. The last member of the Churche family to live at the mansion was Saboth Churche, who died in 1717. The mansion, however, remained in the Churche family until the twentieth century, housing an assortment of tenants. The first non-Churche family tenant was William Jackson, who took up residence in the 1700s. In 1930 there were plans to either take it down and export it to the USA or demolish the mansion due to neglect. Edgar Myott and his wife rescued it and started to restore it. As well as a dwelling, the mansion has spent time as a school, shop, restaurant, and a granary and hay store. The architectural historian described Churches Mansion to be among the best timber-framed Elizabethan buildings in Cheshire, in fact 'an outstanding piece of decorated half-timbered architecture'.

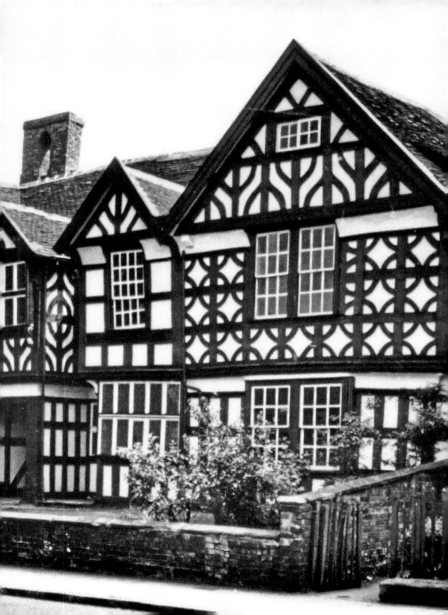

46. NANTWICH MUSEUM, 2016

Walking back down Church Street and through the Cocoa House Yard into Pillory Street, the first building we come to on the left is the Nantwich Museum – and what an excellent museum it is. After visiting the awful Millennium Dome, I wrote in the *Mail on Sunday* that the small museum in Nantwich was far superior to it, and so it is. Here you will find galleries that present the history of Nantwich through the years including the days when Nantwich was a salt town, the Great Fire, the Romans in the town, Tudor times and all of the Tudor buildings that Nantwich is surely proud of. There is an important cheese-making exhibition. The attractive red-brick building was originally the town's library and the museum was founded in 1980. The building originally stood on the site of the town jail. This could the reason that the road is called Pillory Street and there are a set of stocks or pillories opposite. I believe that they also sell a good selection of local history books.

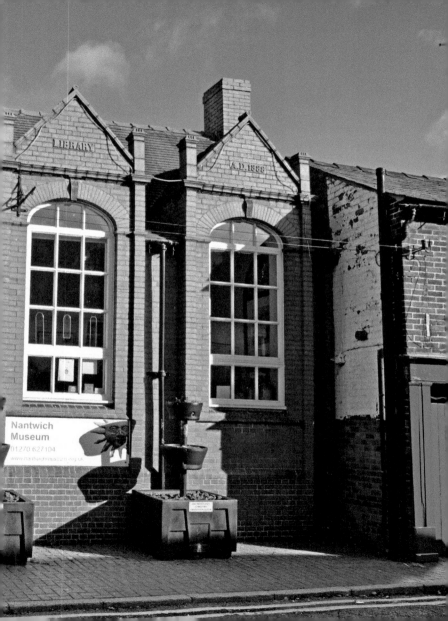

47. PILLORY STREET, *c.* 1915

Standing by the museum in Pillory Street and looking towards the High Street. The large red-brick building in the old photo is the Victoria Cocoa House, where good accommodation could be had for commercials and cyclists, but they should not expect any alcoholic drinks. The museum was then Nantwich Library and is now the museum – a jewel in the already bejewelled crown of Nantwich .Unfortunately the blue Ferrari does not belong to the photographer!

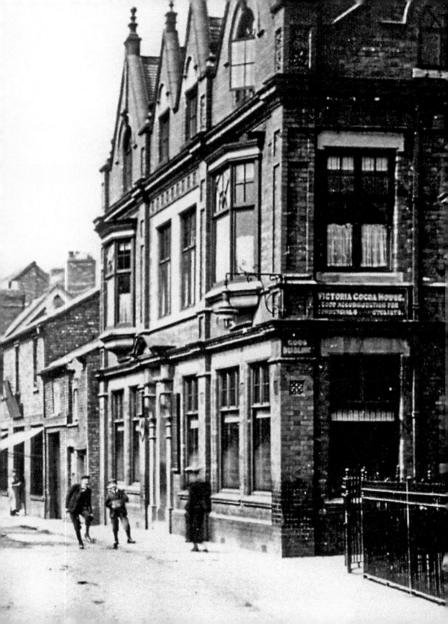

VICTORIA COCOA HOUSE.
GOOD ACCOMMODATION FOR
COMMERCIALS AND CYCLISTS.

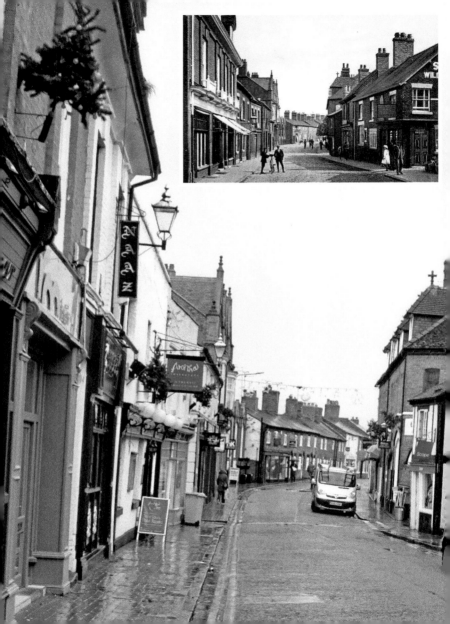

48. PILLORY STREET, EARLY 1900s

Looking towards the Cocoa House building and Nantwich Museum in around 1915 where an attractive, tinted photograph has been used. The White Horse pub can be seen on the right and the tall Cocoa House building on the far left, just before the museum.

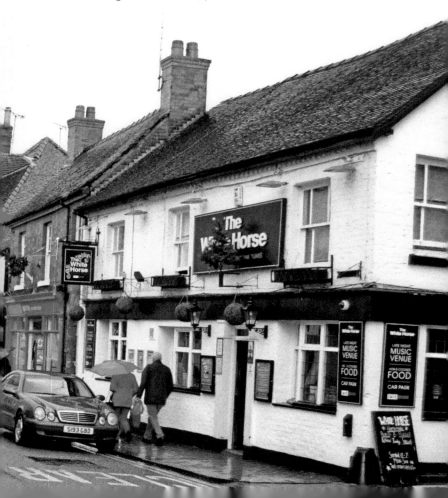

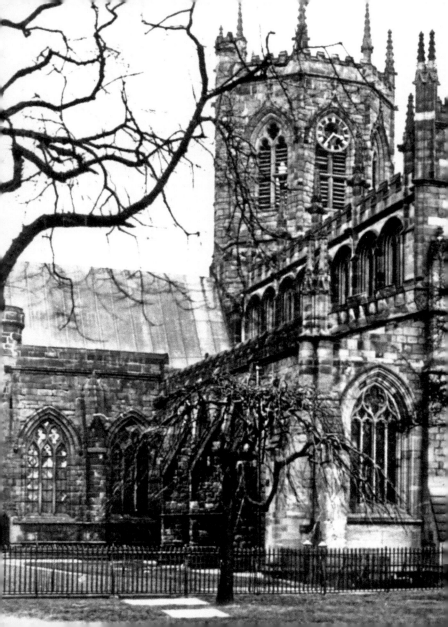

Contents

Amazing Places

The world is full of
amazing places.

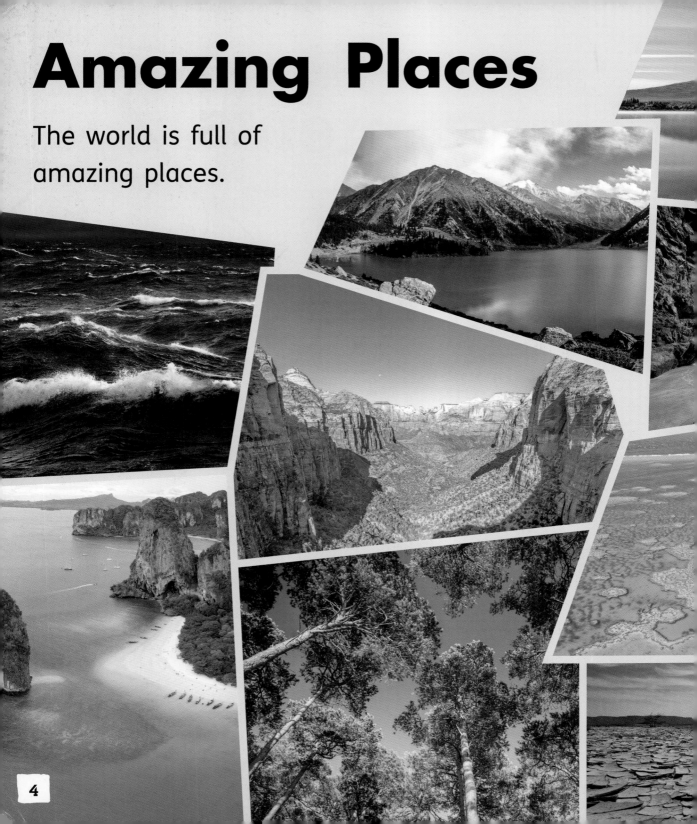

Highest Mountain, Deepest Canyon

Kate Scott

Explorer Challenge

Find out what this is ...

OXFORD
UNIVERSITY PRESS

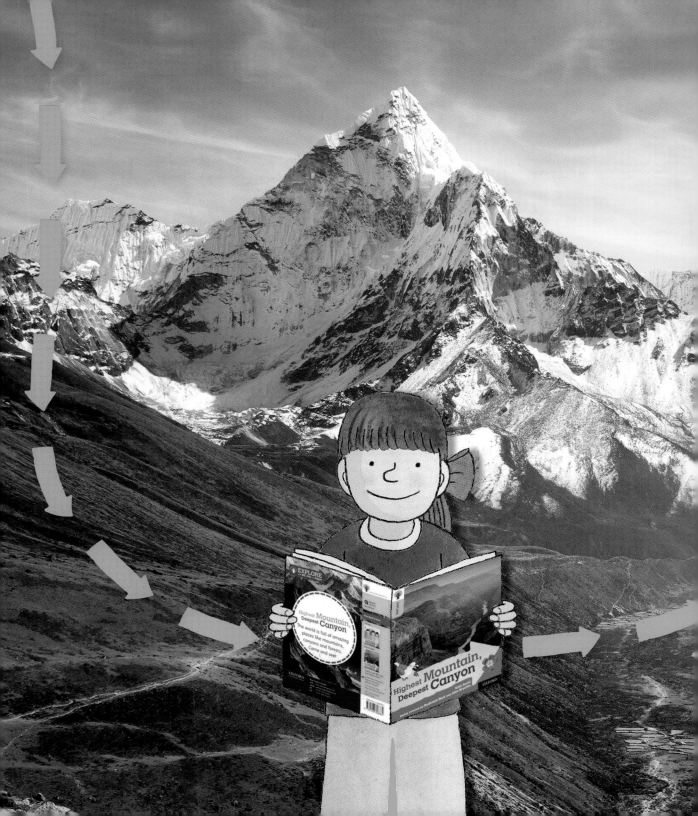

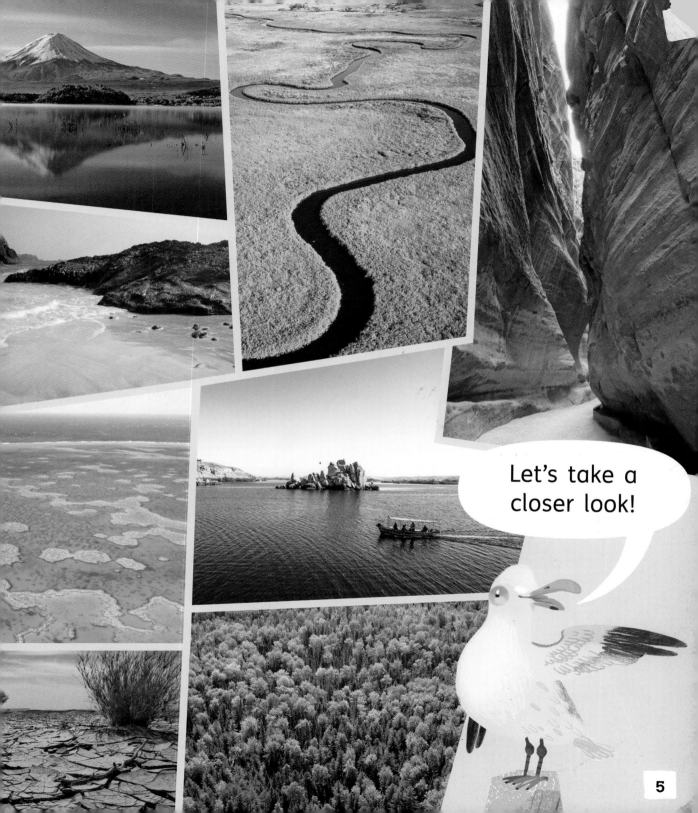

Let's take a closer look!

5

Mountains

Mountains are very high hills.

This is the highest mountain in the world!

Mount Everest is 8848 metres high. That is the same as 177 football pitches laid end to end.

6

The first climbers reached the **summit** in 1953.

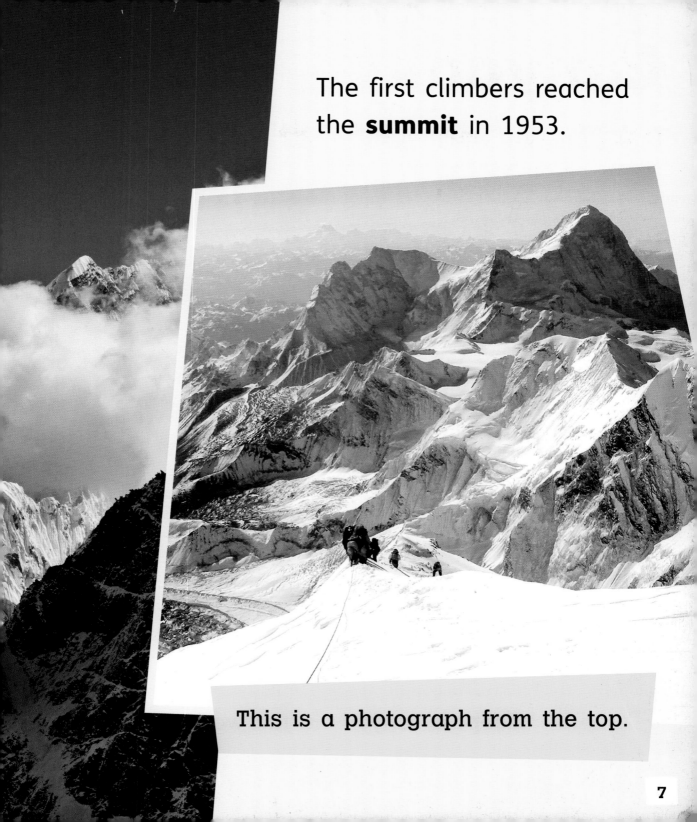

This is a photograph from the top.

Canyons

A canyon is a deep **valley**.

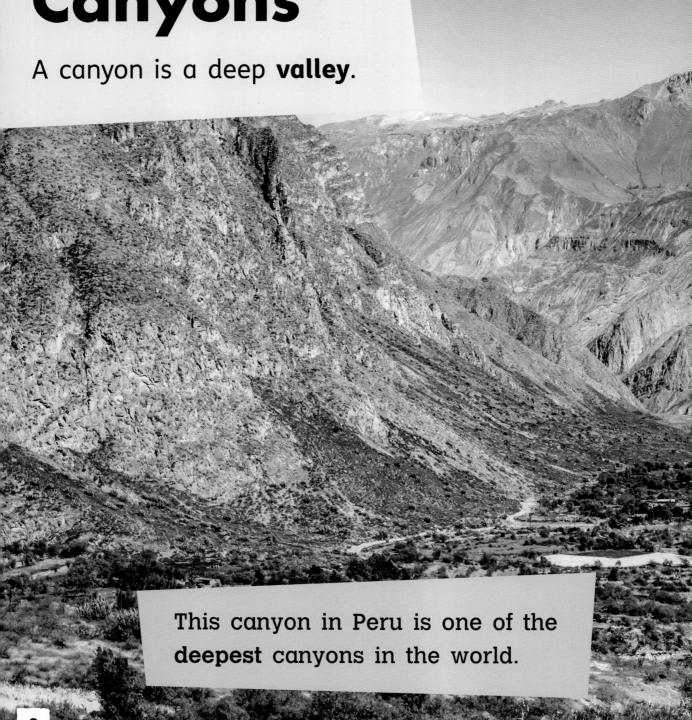

This canyon in Peru is one of the **deepest** canyons in the world.

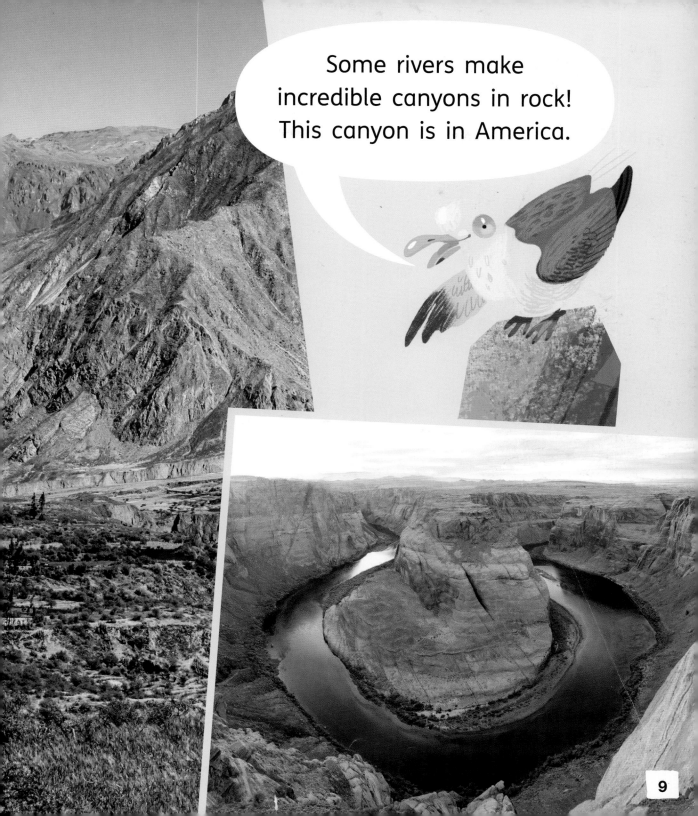

Some rivers make incredible canyons in rock! This canyon is in America.

Lakes

Lakes are areas of water surrounded by land. There are 117 million lakes in the world!

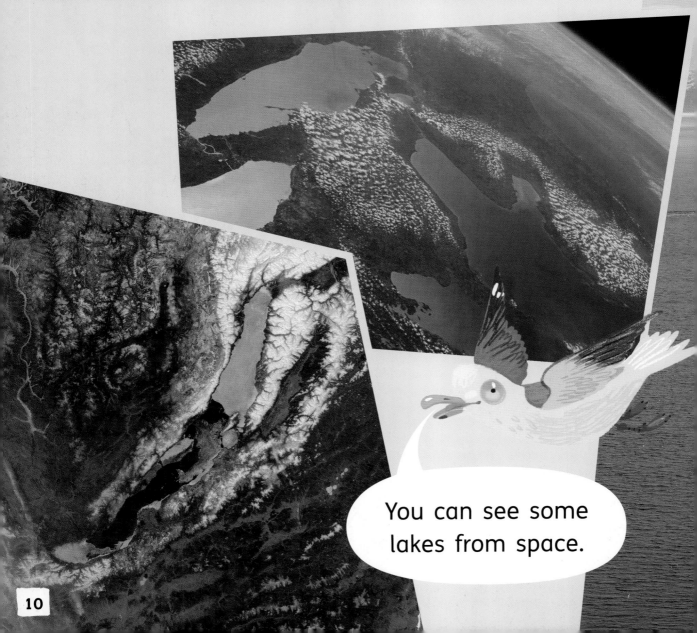

You can see some lakes from space.

This lake in Russia is the deepest and oldest lake in the world. It is 1643 metres deep. That is the same as 33 football pitches.

Rivers

Rivers are big streams of water.

These are the longest and largest rivers in the world.

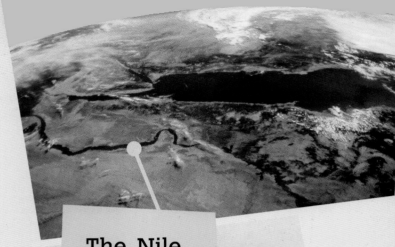

The Nile

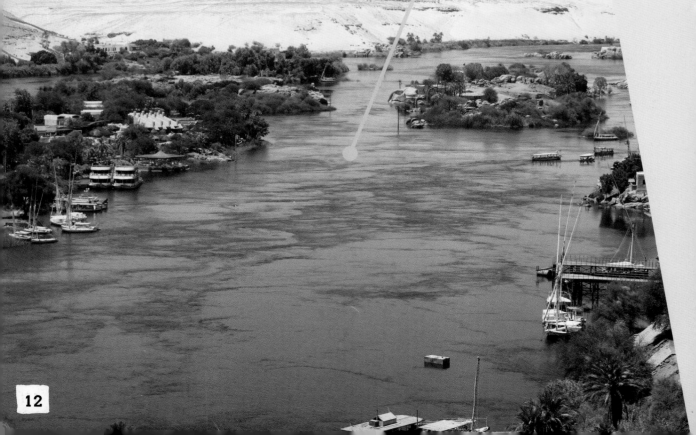

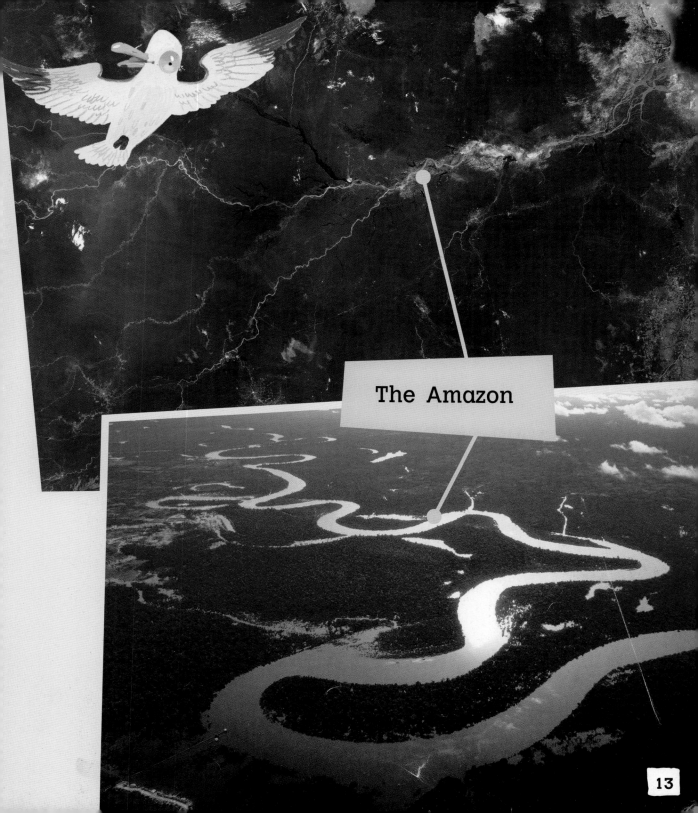

The Amazon

Beaches

Beaches are strips of **pebbles** or sand by the sea.

Beaches come in all sizes – from this tiny beach ...

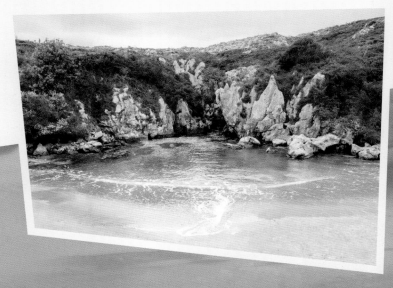

... to this long beach.

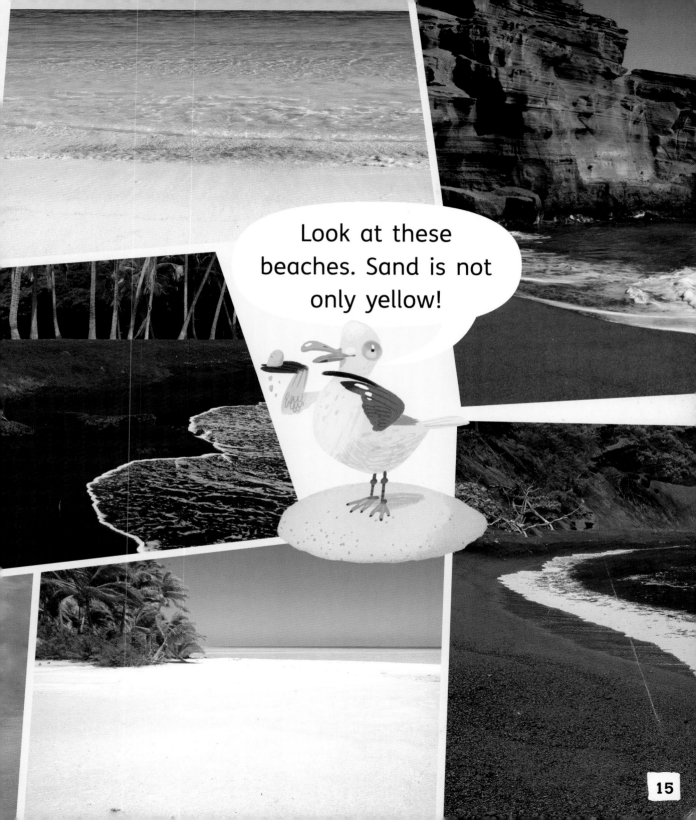

15

Oceans

An ocean is an area of the sea.

The Pacific is the largest and deepest ocean in the world.

The deepest part is the same as 220 football pitches. It is deeper than Mount Everest is high!

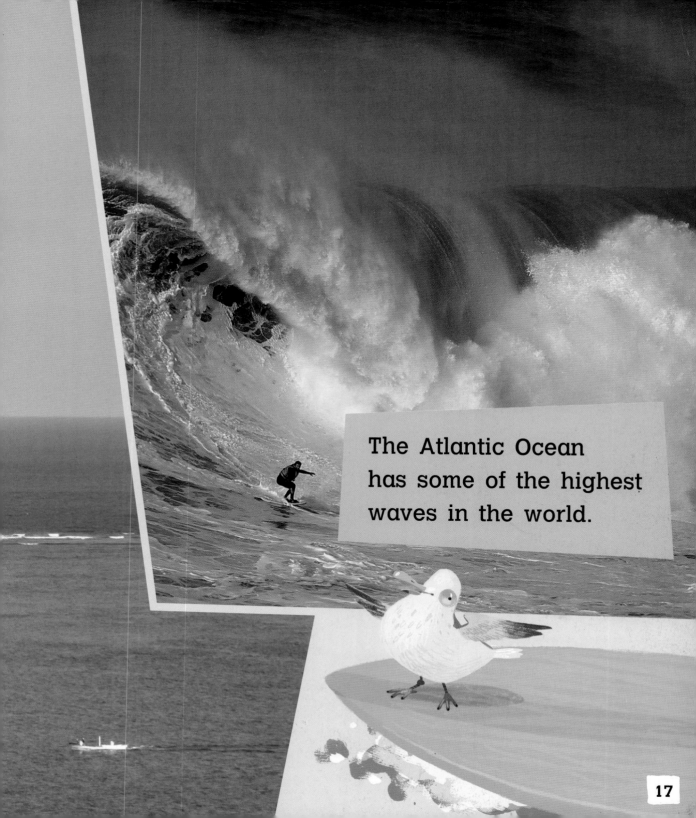

The Atlantic Ocean
has some of the highest
waves in the world.

Deserts

Deserts are dry areas of land.

The driest sand desert in the world is the Atacama.

It has not rained in some parts of the Atacama Desert for over 400 years!

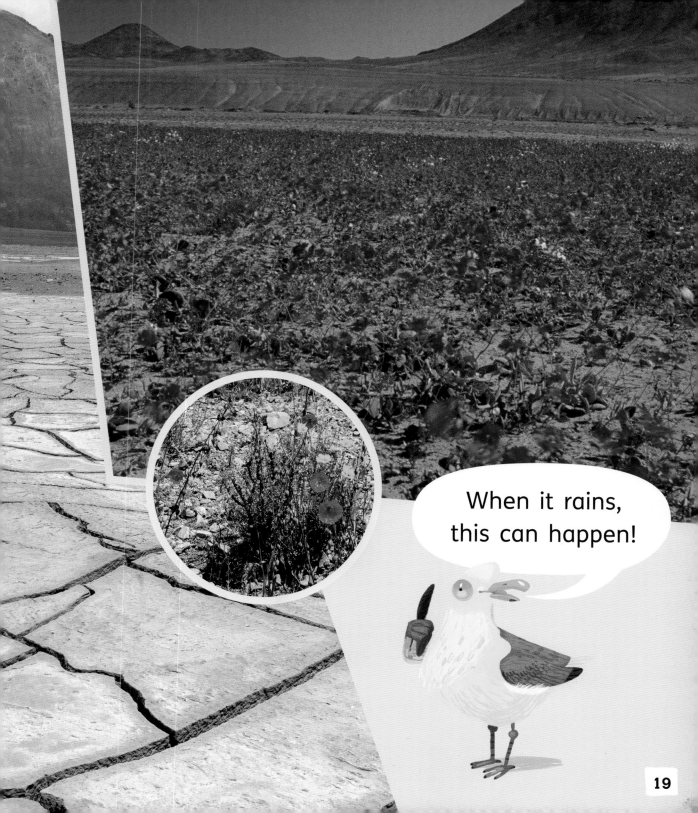

When it rains,
this can happen!

19

Forests

Forests are areas with lots of trees.

The Amazon is a **rainforest**. It is the largest rainforest in the world.

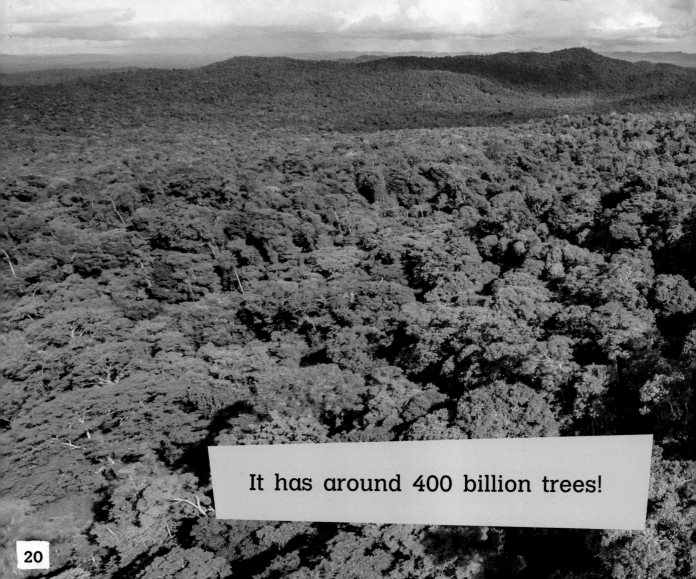

It has around 400 billion trees!

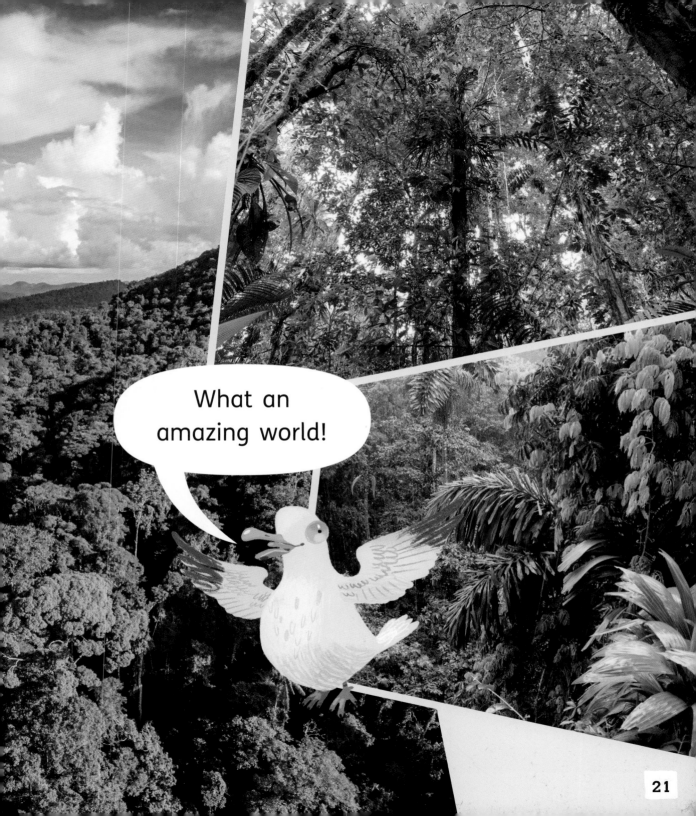

Glossary

deepest: the longest way down

pebbles: small stones

rainforest: a place with lots of trees and lots of rain

summit: the top of something

valley: the dip in between hills

Index

Look Back, Explorers

Can you name one of the longest and largest rivers in the world?

What is a desert?

Can you think of any words to describe the pictures of the oceans on pages 16–17?

What can happen in the desert when it rains?

Did you find out what this is?

What's Next, Explorers?

Now that you've read about lots of amazing places, join Biff, Chip and Nadim at Camel-Back Mountain ...

Explorer Challenge
for *Camel-Back Mountain*

Look out for the different activities people do on the mountain ...